> There is only one good. And that is to act according to the dictates of one's conscience.

simone de beauvoir's little book of selected quotes

Self-knowledge is no
guarantee of happiness,
but it is on the side
of happiness and can
supply the courage to
fight for it.

simone de beauvoir's
little book of
selected quotes

Only a woman can
write what it is
to feel as a woman,
to be a woman.

simone de beauvoir's
little book of
selected quotes

I would certainly like to see some young women take up psychoanalysis seriously and reconstruct it from an absolutely new viewpoint.

simone de beauvoir's little book of selected quotes

That's what I consider true generosity. You give your all, and yet you always feel as if it costs you nothing.

simone de beauvoir's
little book of
selected quotes

To emancipate woman is to refuse to confine her to the relations she bears to man, not to deny them to her; let her have her independent existence and she will continue nonetheless to exist for him also: mutually recognizing each other as subject, each will yet remain for the other an other...when we abolish the slavery of half of humanity, together with the whole system of hypocrisy that it implies, then the 'division' of humanity will reveal its genuine significance and the human couple will find its true form.

simone de beauvoir's
little book of
selected quotes

Literature is always what the dominant ideology recognizes as literature.

simone de beauvoir's little book of selected quotes

Oppression tries to defend itself by its utility. But we have seen that it is one of the lies of the serious mind to attempt to give the word "useful" an absolute meaning; nothing is useful if it is not useful to man; nothing is useful to man if the latter is not in a position to define his own ends and values, if he is not free.

simone de beauvoir's
little book of
selected quotes

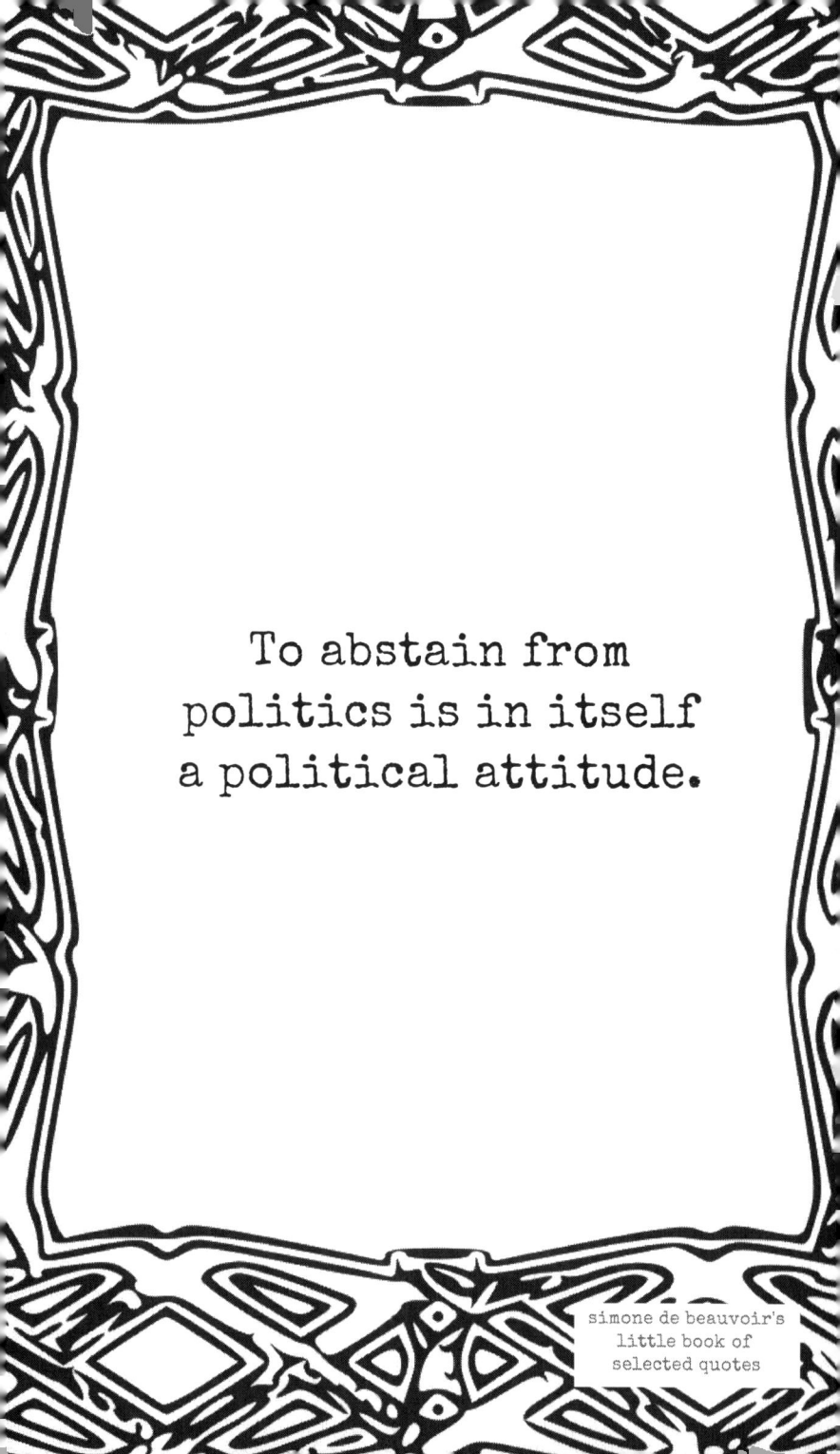

To abstain from politics is in itself a political attitude.

simone de beauvoir's little book of selected quotes

There is the problem of unpaid labor, such as housework, which represents millions and millions of unsalaried work hours and on which masculine society is firmly based. To put an end to this would be to send the present-day capitalist system flying in a single blow. Only we can't do it by ourselves; there have to be other kinds of attacks on the system. So a certain alliance with revolutionary systems is necessary, even masculine ones.

simone de beauvoir's
little book of
selected quotes

--There you are. The sight of the changing world is miraculous and heartbreaking, both at the same time.
--But so it is for me too. The heartbreaking side of growing old is not in the things around one but in oneself.

simone de beauvoir's little book of selected quotes

The body is not a thing, it is a situation: it is our grasp on the world and our sketch of our project.

simone de beauvoir's little book of selected quotes

Patience is one of those feminine qualities which have their origin in our oppression but should be preserved after our liberation.

simone de beauvoir's little book of selected quotes

Can one say that there is a way of crying out, of speaking, which is properly feminine? Personally, I don't think so. In the end, I find this is another way of putting women in a kind of singularity, a ghetto, which is not what I want. I want them to be singular and universal at the same time.

simone de beauvoir's little book of selected quotes

Be loved, be admired,
be necessary;
be somebody.

simone de beauvoir's
little book of
selected quotes

In every society the artist or writer remains an outsider.

simone de beauvoir's
little book of
selected quotes

Each of us is responsible for everything and to every human being.

simone de beauvoir's
little book of
selected quotes

Between women love is contemplative; caresses are intended less to gain possession of the other than gradually to re-create the self through her; separateness is abolished, there is no struggle, no victory, no defeat; in exact reciprocity each is at once subject and object, sovereign and slave; duality become mutuality.

simone de beauvoir's little book of selected quotes

To give space when what one most yearns for is closeness, that is both the great test and great tragedy of love.

simone de beauvoir's little book of selected quotes

Whatever the country, capitalist or socialist, man was everywhere crushed by technology, made a stranger to his own work, imprisoned, forced into stupidity. The evil all arose from the fact that he had increased his needs rather than limited them; ... As long as fresh needs continued to be created, so new frustrations would come into being. When had the decline begun? The day knowledge was preferred to wisdom and mere usefulness to beauty. ... Only a moral revolution - not a social or political revolution - only a moral revolution would lead man back to his lost truth.

simone de beauvoir's
little book of
selected quotes

When we abolish the slavery of half of humanity, together with the whole system of hypocrisy it implies, then the "division" of humanity will reveal its genuine significance and the human couple will find its true form.

simone de beauvoir's little book of selected quotes

That is what chills your spine when you read an account of a suicide: not the frail corpse hanging from the window bars but what happened inside that heart immediately before.

simone de beauvoir's
little book of
selected quotes

Most feminists in France came to feminism after '68 as a result of the hypocrisy they experienced in leftist movements. In these movements, where everyone believed there was going to be true equality, fraternity between men and women, and that together they were going to struggle against this rotten society, even there they noticed that the leftists, the militants, kept them "in their place." Women made the coffee while the others did the talking; they were the ones who typed the letters.

simone de beauvoir's little book of selected quotes

A freedom which is interested only in denying freedom must be denied. And it is not true that the recognition of the freedom of others limits my own freedom: to be free is not to have the power to do anything you like; it is to be able to surpass the given toward an open future; the existence of others as a freedom defines my situation and is even the condition of my own freedom. I am oppressed if I am thrown into prison, but not if I am kept from throwing my neighbor into prison.

simone de beauvoir's
little book of
selected quotes

No one is more arrogant toward women, more aggressive or scornful, than the man who is anxious about his virility.

simone de beauvoir's little book of selected quotes

To catch a husband
is an art; to hold
him is a job.

simone de beauvoir's
little book of
selected quotes

Sex pleasure in woman is a kind of magic spell; it demands complete abandon; if words or movements oppose the magic of caresses, the spell is broken.

simone de beauvoir's little book of selected quotes

The most mediocre of males feels himself a demigod as compared with women.

simone de beauvoir's little book of selected quotes

It was easier for me to think of a world without a creator than of a creator loaded with all the contradictions of the world.

simone de beauvoir's little book of selected quotes

Youth and what the Italians so prettily call stamina. The vigor, the fire, that enables you to love and create. When you've lost that, you've lost everything.

simone de beauvoir's
little book of
selected quotes

The nearer I come to the end of my days, the more I am enabled to see that strange thing, a life, and to see it whole.

simone de beauvoir's
little book of
selected quotes

Marriage is a career which brings about more benefits than many others.

simone de beauvoir's
little book of
selected quotes

She was ready to deny the existence of space and time rather than admit that love might not be eternal.

simone de beauvoir's little book of selected quotes

Every time I start on a new book, I am a beginner again. I doubt myself, I grow discouraged, all the work accomplished in the past is as though it never was, my first drafts are so shapeless that it seems impossible to go on with the attempt at all, right up until the moment - always imperceptible, there, too, there is a break - when it is has become impossible not to finish it.

simone de beauvoir's
little book of
selected quotes

I think that where you go wrong is that you imagine that your reasons for living ought to fall on you, ready-made from heaven, whereas we have to find them for ourselves.

simone de beauvoir's little book of selected quotes

It is true that nothing is gained without something being lost: everyone knows that in fulfilling oneself one necessarily sacrifices some possibilities.

simone de beauvoir's
little book of
selected quotes

Change your life today. Don't gamble on the future, act now, without delay.

simone de beauvoir's
little book of
selected quotes

However gifted an individual is at the outset, if his or her talents cannot be developed because of his or her social condition, because of the surrounding circumstances, these talents will be still-born.

simone de beauvoir's little book of selected quotes

I should like to be the landscape which I am contemplating, I should like this sky, this quiet water to think themselves within me, that it might be I whom they express in flesh and bone, and I remain at a distance. But it is also by this distance that the sky and the water exist before me. My contemplation is an excruciation only because it is also a joy. I can not appropriate the snow field where i slide. It remains foreign, forbidden, but I take delight in this very effort toward an impossible possession. I experience it as a triumph, not as a defeat.

simone de beauvoir's
little book of
selected quotes

Existentialism does not offer to the reader the consolations of an abstract evasion: existentialism proposes no evasion. On the contrary, its ethics is experienced in the truth of life, and it then appears as the only proposition of salvation which one can address to men.

simone de beauvoir's
little book of
selected quotes

Society turns away from the aged worker as though he belonged to another species. That is why the whole question is buried in a conspiracy of silence. Old age exposes the failure of our entire civilization.

simone de beauvoir's little book of selected quotes

It is not in giving life but in risking life that man is raised above the animal; that is why superiority has been accorded in humanity not to the sex that brings forth but to that which kills.

simone de beauvoir's
little book of
selected quotes

Let women be provided with living strength of their own. Let them have the means to attack the world and wrest from it their own subsistence, and their dependence will be abolished -- that of man also.

simone de beauvoir's little book of selected quotes

Life is occupied in both perpetuating itself and in surpassing itself; if all it does is maintain itself, then living is only not dying.

simone de beauvoir's
little book of
selected quotes

I tore myself away from the safe comfort of certainties through my love for truth – and truth rewarded me.

simone de beauvoir's
little book of
selected quotes

Defending the truth is not something one does out of a sense of duty or to allay guilt complexes, but is a reward in itself.

simone de beauvoir's
little book of
selected quotes

In a way, literature is true than life,' he said to himself. 'On paper, you say exactly and completely what you feel. How easy it is to break things off on paper! You hate, you shout, you kill, you commit suicide; you carry things to the very end. And that's why it's false. But it's damned satisfying. In life, you're constantly denying yourself, and others are always contradicting you. On paper, I make time stand still and I impose my convictions on the whole world; they become the only reality.

simone de beauvoir's little book of selected quotes

The characteristic feature of all ethics is to consider human life as a game that can be won or lost and to teach man the means of winning.

simone de beauvoir's
little book of
selected quotes

I am awfully greedy;
I want everything from
life. I want to be a woman
and to be a man, to have
many friends and to have
loneliness, to work much
and write good books, to
travel and enjoy myself,
to be selfish and to be
unselfish... You see, it is
difficult to get all which
I want. And then when I do
not succeed I get mad
with anger.

simone de beauvoir's
little book of
selected quotes

...counselling man to treat her as a slave while persuading her that she is a queen.

simone de beauvoir's
little book of
selected quotes

Authentic love must be founded on reciprocal recognition of two freedoms. For each of them, love would be the revelation of the self through the gift of the self and the enrichment of the universe.

simone de beauvoir's little book of selected quotes

The emancipation of women must be the work of women themselves, independent of the class struggle.

simone de beauvoir's
little book of
selected quotes

...but all day long I would be training myself to think, to understand, to criticize, to know myself; I was seeking for the absolute truth: this preoccupation did not exactly encourage polite conversation.

simone de beauvoir's little book of selected quotes

What an odd thing a diary is: the things you omit are more important than those you put in.

simone de beauvoir's little book of selected quotes

At the moment of their emancipation, women have a need to write their own histories.

simone de beauvoir's
little book of
selected quotes

Society cares about the individual only in so far as he is profitable. The young know this. Their anxiety as they enter in upon social life matches the anguish of the old as they are excluded from it.

simone de beauvoir's little book of selected quotes

As long as the family and the myth of the family ... have not been destroyed, women will still be oppressed.

simone de beauvoir's little book of selected quotes

In itself, homosexuality is as limiting as heterosexuality: the ideal should be to be capable of loving a woman or a man; either, a human being, without feeling fear, restraint, or obligation.

simone de beauvoir's little book of selected quotes

Woman is shut up in a kitchen or in a boudoir, and astonishment is expressed that her horizon is limited. Her wings are clipped, and it is found deplorable that she cannot fly.

simone de beauvoir's little book of selected quotes

The women of today are in a fair way to dethrone the myth of femininity; they are beginning to affirm their independence in concrete ways; but they do not easily succeed in living completely the life of a human being.

simone de beauvoir's little book of selected quotes

Regardless of the staggering dimensions of the world about us, the density of our ignorance, the risks of catastrophes to come, and our individual weakness within the immense collectivity, the fact remains that we are absolutely free today if we choose to will our existence in its finiteness, a finiteness which is open on the infinite. And in fact, any man who has known real loves, real revolts, real desires, and real will knows quite well that he has no need of any outside guarantee to be sure of his goals; their certitude comes from his own drive.

simone de beauvoir's
little book of
selected quotes

The state of emotional intoxication allows one to grasp existence in one's self and in the other, as both subjectivity and passivity. The two partners merge in this ambiguous unity; each one is freed of his own presence and achieves immediate communication with the other.

simone de beauvoir's
little book of
selected quotes

Men create their own gods and thus have some slight understanding that they are self-fabricated. Women are much more susceptible, because they are completely oppressed by men; they take men at their word and believe in the gods that men have made up. The situation of women, their culture, makes them kneel more often before the gods that have been created by men than men themselves do, who know what they've done. To this extent, women will be more fanatical, whether it is for fascism or for totalitarianism.

simone de beauvoir's little book of selected quotes

There are topics
which are common
to men and women.
I think that if a woman
speaks of oppression,
of misery, she will
speak of it in exactly
the same way as a man.
But if she speaks of her
own personal problems
as a woman, she will
obviously speak in
another way.

simone de beauvoir's
little book of
selected quotes

In 1949, I believed that social progress, the triumph of the proletariat, socialism would lead to the emancipation of women. But I saw that nothing came of it: first of all, that socialism was not achieved anywhere, and that in certain countries which called themselves socialist, the situation of women was no better than it was in so-called capitalist countries.

simone de beauvoir's little book of selected quotes

Why does one exist? That's not my problem. One does exist. The thing to do is to take no notice but go at it on the run and to keep on going right on until you die.

simone de beauvoir's
little book of
selected quotes

One's life has value so long as one attributes value to the life of others, by means of love, friendship, indignation and compassion.

simone de beauvoir's
little book of
selected quotes

You have to start from where you are today and from what can be done.

simone de beauvoir's
little book of
selected quotes

To be free is not to have the power to do anything you like; it is to be able to surpass the given toward an open future.

simone de beauvoir's little book of selected quotes

As soon as a woman refuses to be perfectly happy doing housework eight hours a day, society has a tendency to want to do a lobotomy on her.

simone de beauvoir's
little book of
selected quotes

What is an adult?
A child blown up
by age.

simone de beauvoir's
little book of
selected quotes

I had never believed in the sacred nature of literature. God had died when I was fourteen.

simone de beauvoir's
little book of
selected quotes

On the day when it will be possible for woman to love not in her weakness but in her strength, not to escape herself but to find herself, not to abase herself but to assert herself--on that day love will become for her, as for man, a source of life and not of mortal danger.

simone de beauvoir's little book of selected quotes

Old age was growing inside me. It kept catching my eye from the depths of the mirror. I was paralyzed sometimes as I saw it making its way toward me so steadily when nothing inside me was ready for it.

simone de beauvoir's
little book of
selected quotes

It's important that you think of your relationship with the world and the way you can express that world and that you not be stopped if it scandalizes or embarrasses; but you must not look for scandal or for the avant-garde as a thing in itself.

simone de beauvoir's
little book of
selected quotes

I wish that every human life might be pure transparent freedom.

simone de beauvoir's
little book of
selected quotes

No existence can be validly fulfilled if it is limited to itself.

simone de beauvoir's
little book of
selected quotes

To show your true ability is always, in a sense, to surpass the limits of your ability, to go a little beyond them: to dare, to seek, to invent; it is at such a moment that new talents are revealed, discovered, and realized.

simone de beauvoir's little book of selected quotes

I never thought of myself as being in the avant-garde. I said what I had to say, as I was able to say it.

simone de beauvoir's
little book of
selected quotes

No woman should be authorized to stay at home and raise her children. Society should be totally different. Women should not have that choice, precisely because if there is such a choice, too many women will make that one.

simone de beauvoir's little book of selected quotes

I am too intelligent, too demanding, and too resourceful for anyone to be able to take charge of me entirely. No one knows me or loves me completely. I have only myself.

simone de beauvoir's
little book of
selected quotes

It must be said in addition that the men with the most scrupulous respect for embryonic life are also those who are most zealous when it comes to condemning adults to death in war.

simone de beauvoir's little book of selected quotes

The curse which lies upon marriage is that too often the individuals are joined in their weakness rather than in their strength, each asking from the other instead of finding pleasure in giving. It is even more deceptive to dream of gaining through the child a plenitude, a warmth, a value, which one is unable to create for oneself; the child brings joy only to the woman who is capable of disinterestedly desiring the happiness of another, to one who without being wrapped up in self seeks to transcend her own existence.

simone de beauvoir's little book of selected quotes

One is not born, but rather becomes, a woman. No biological, psychological, or economic fate determines the figure that the human female presents in society; it is civilization as a whole that produces this creature, intermediate between male and eunuch, which is described as feminine.

simone de beauvoir's little book of selected quotes

I am incapable of conceiving infinity, and yet I do not accept finity. I want this adventure that is the context of my life to go on without end.

simone de beauvoir's little book of selected quotes

All oppression
creates a state
of war.

simone de beauvoir's
little book of
selected quotes

Few tasks are more like the torture of Sisyphus than housework, with its endless repetition: the clean becomes soiled, the soiled is made clean, over and over, day after day. The housewife wears herself out marking time: she makes nothing, simply perpetuates the present ... Eating, sleeping, cleaning – the years no longer rise up towards heaven, they lie spread out ahead, grey and identical. The battle against dust and dirt is never won.

simone de beauvoir's little book of selected quotes

There is only one solution if old age is not to be an absurd parody of our former life, and that is to go on pursuing ends that give our existence a meaning.

simone de beauvoir's little book of selected quotes

To be feminist doesn't mean simply to do nothing, to reduce yourself to total impotence under the pretext of refusing masculine values. There is a problematic, a very difficult dialectic between accepting power and refusing it, accepting certain masculine values, and wanting to transform them. I think it's worth a try.

simone de beauvoir's
little book of
selected quotes

I take on a shape and an existence only if I first throw myself into the world by loving, by doing.

simone de beauvoir's
little book of
selected quotes

The innumerable conflicts that set men and women against one another come from the fact that neither is prepared to assume all the consequences of this situation which the one has offered and the other accepted.

simone de beauvoir's little book of selected quotes

When women act like women, they are accused of being inferior. When women act like human beings, they are accused of behaving like men.

simone de beauvoir's little book of selected quotes

Legislators, priests, philosophers, writers, and scientists have striven to show that the subordinate position of woman is willed in heaven and advantageous on earth.

simone de beauvoir's little book of selected quotes

The point is not for women simply to take power out of men's hands, since that wouldn't change anything about the world. It's a question precisely of destroying that notion of power.

simone de beauvoir's
little book of
selected quotes

It is in the knowledge of the genuine conditions of our lives that we must draw our strength to live and our reasons for living.

simone de beauvoir's
little book of
selected quotes

One can hardly tell women that washing up saucepans is their divine mission, [so] they are told that bringing up children is their divine mission. But the way things are in the world, bringing up children has a great deal in common with washing up saucepans.

simone de beauvoir's little book of selected quotes

It is in great part the anxiety of being a woman that devastates the feminine body.

simone de beauvoir's little book of selected quotes

You have never had any confidence in him. And if he has no confidence in himself it is because he sees himself through your eyes.

simone de beauvoir's little book of selected quotes

To be oneself, simply oneself, is so amazing and utterly unique an experience that it's hard to convince oneself so singular a thing happens to everybody.

simone de beauvoir's
little book of
selected quotes